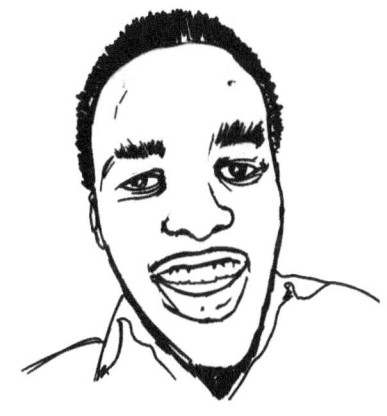

Hi there, my name is Jeff.
I hope you enjoy this coloring book.

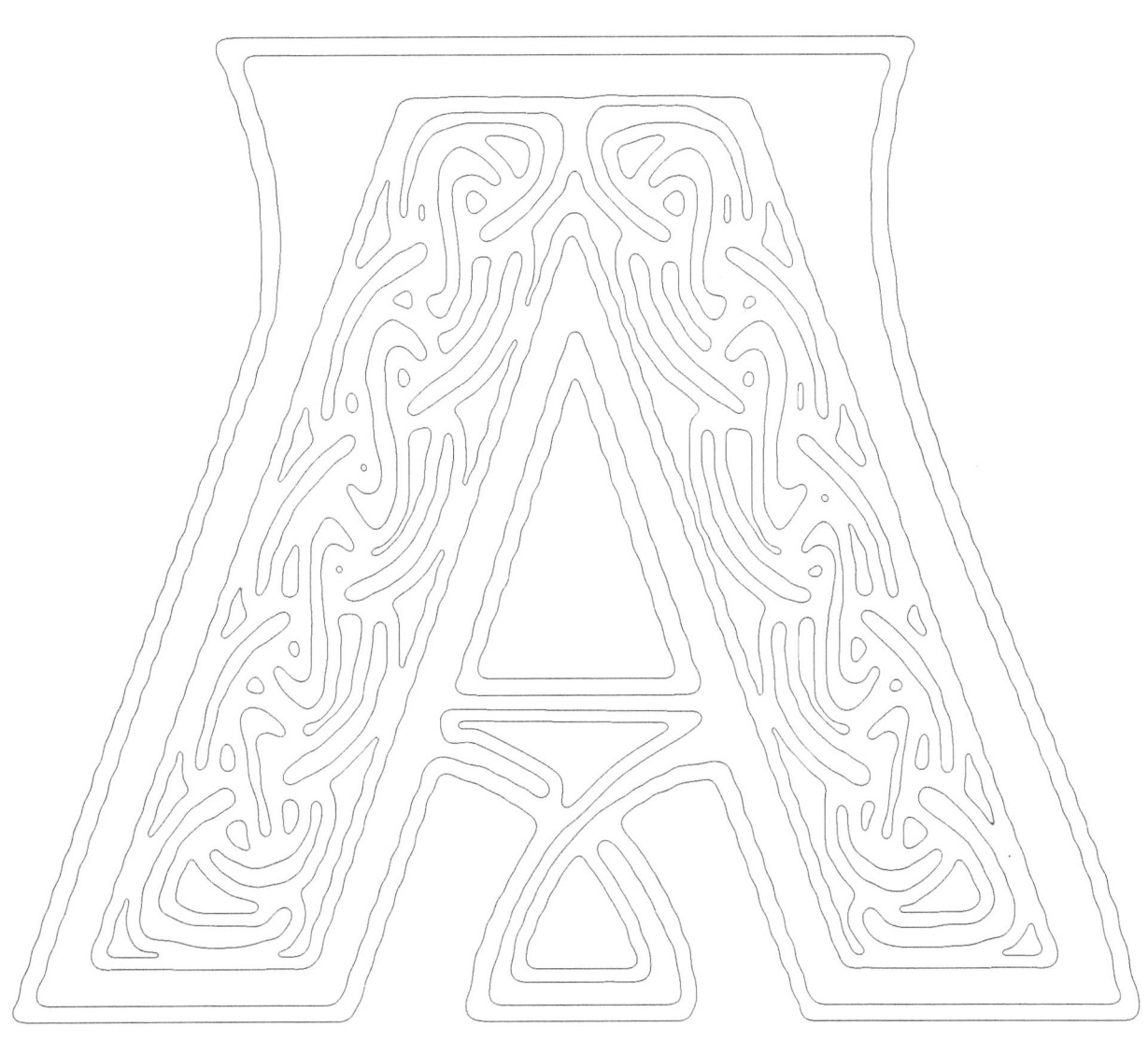

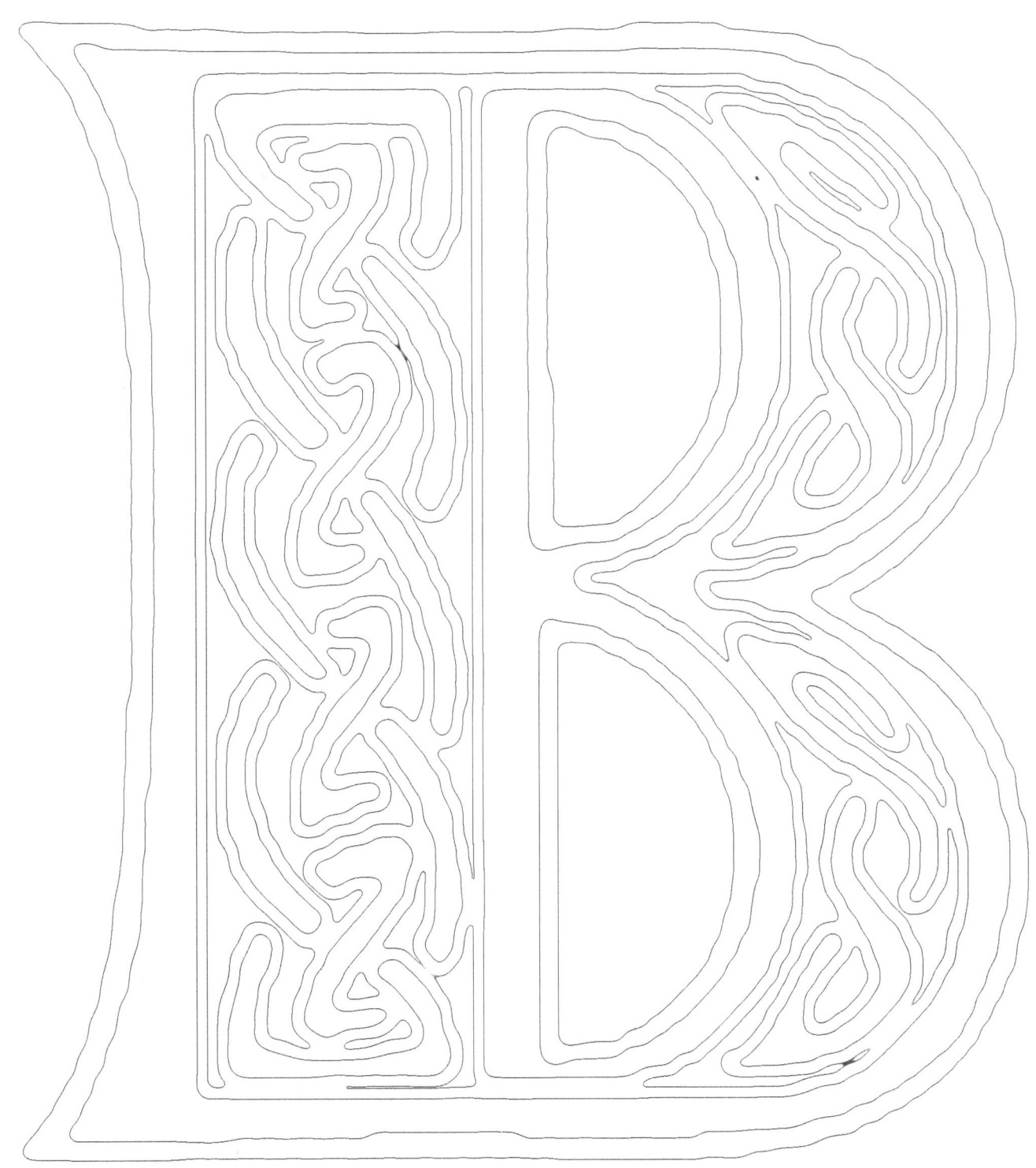

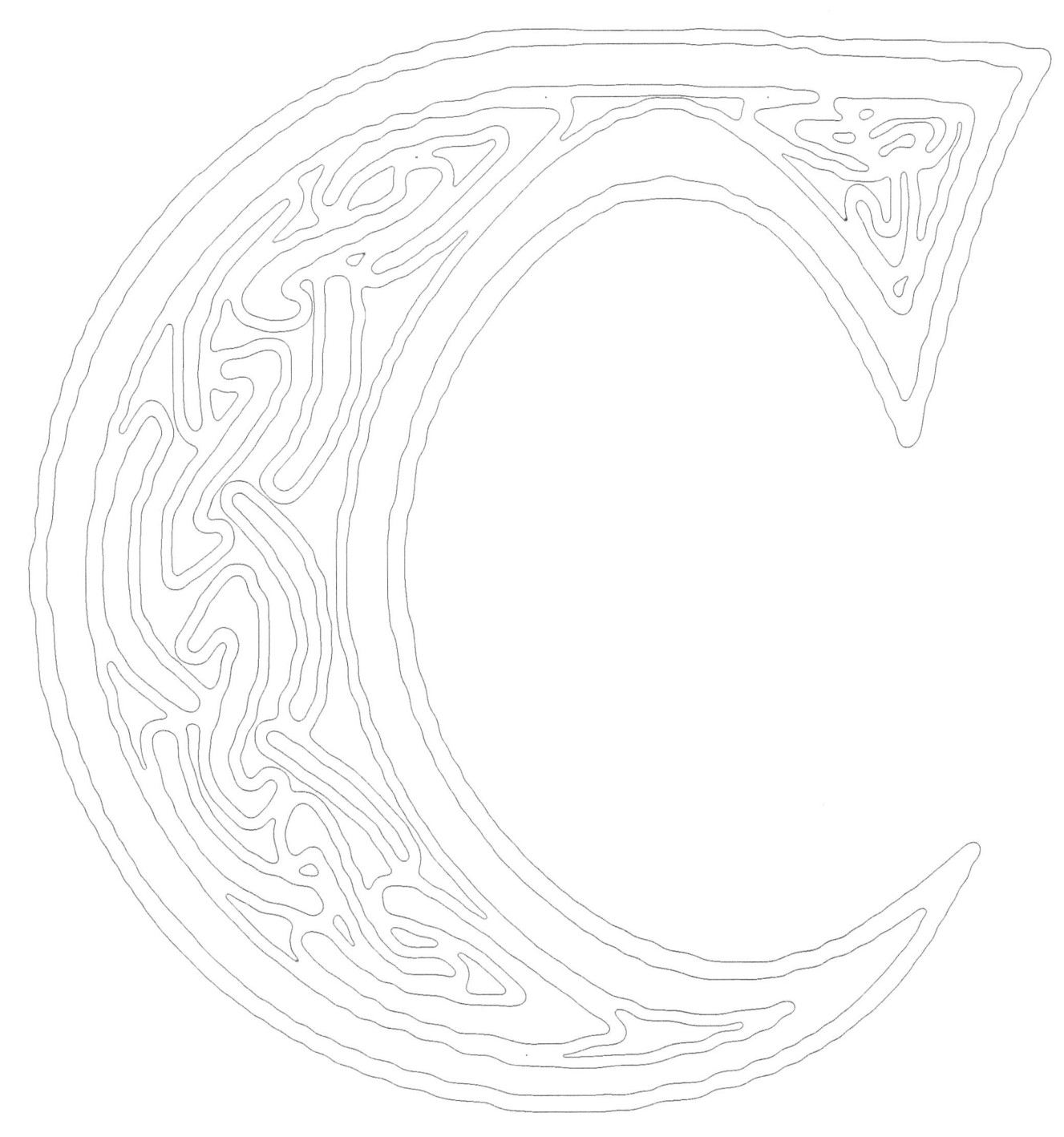

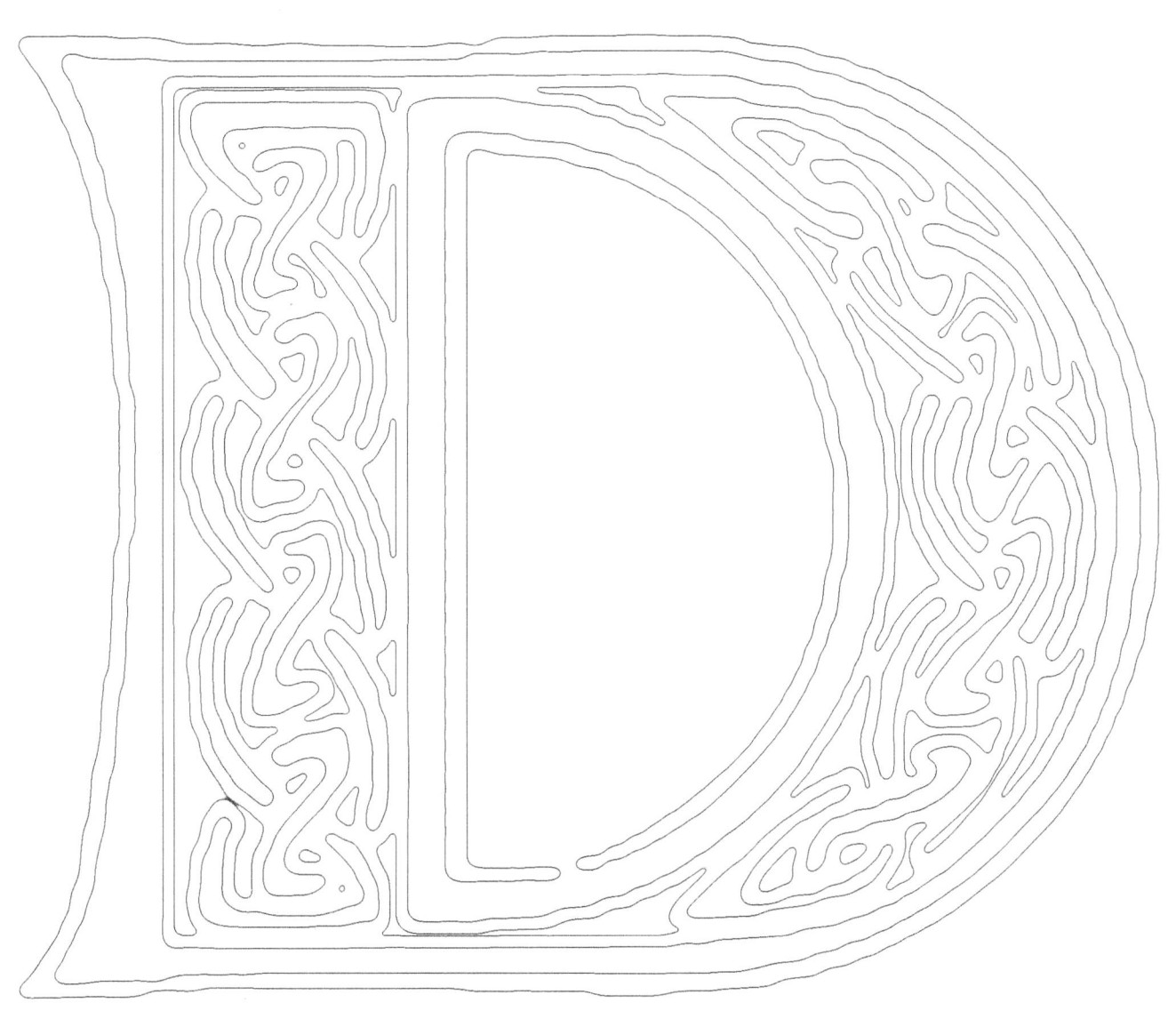

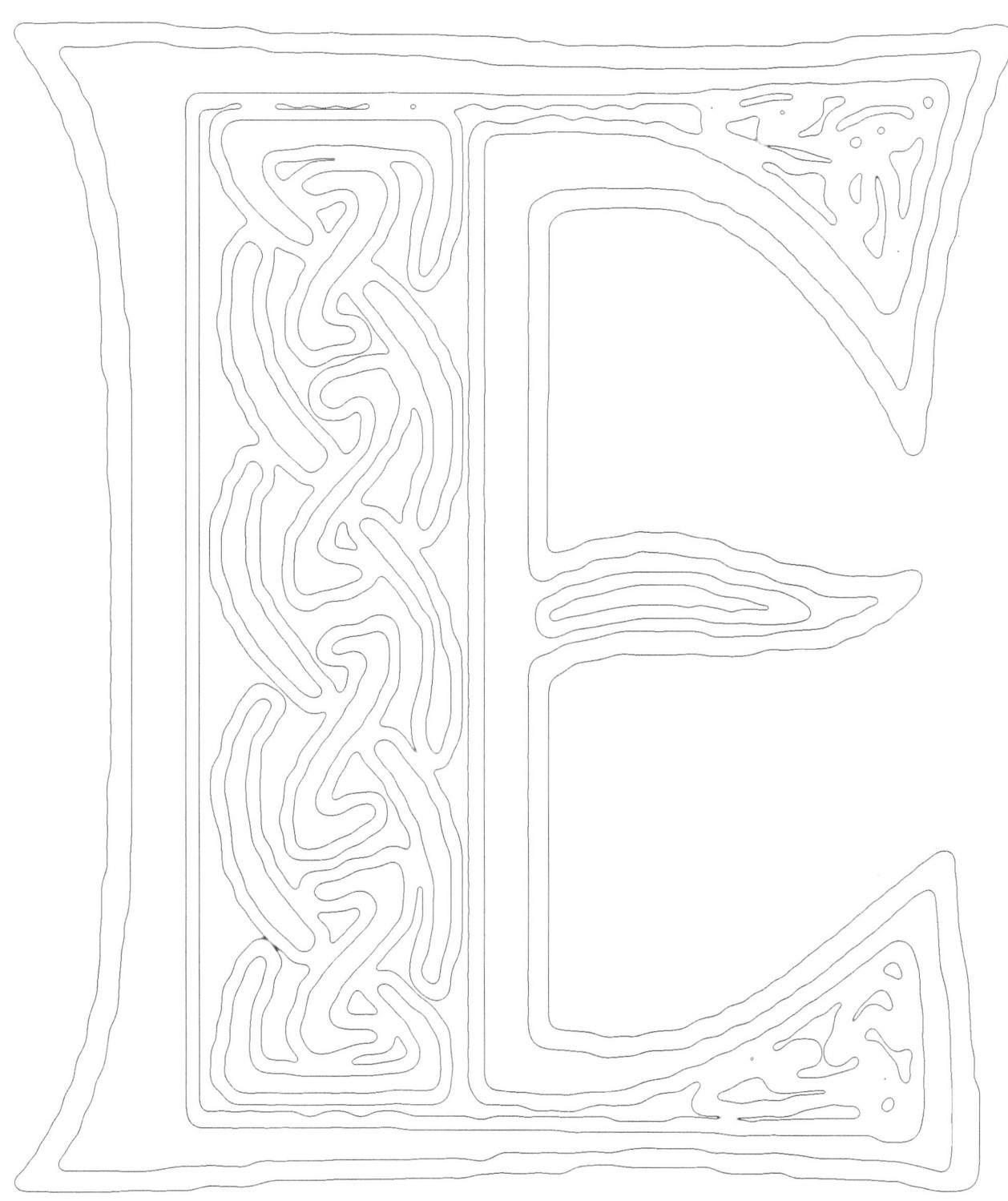

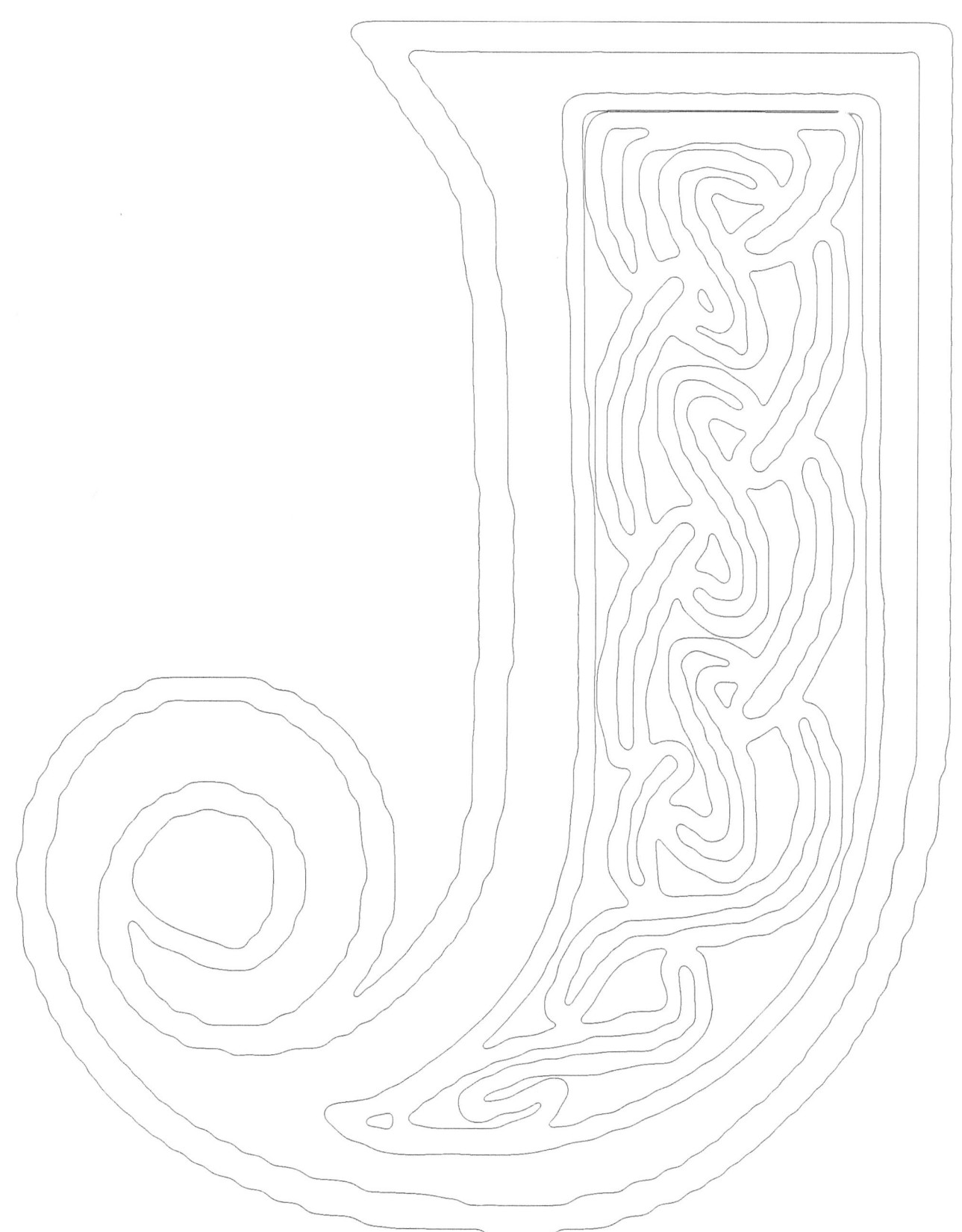

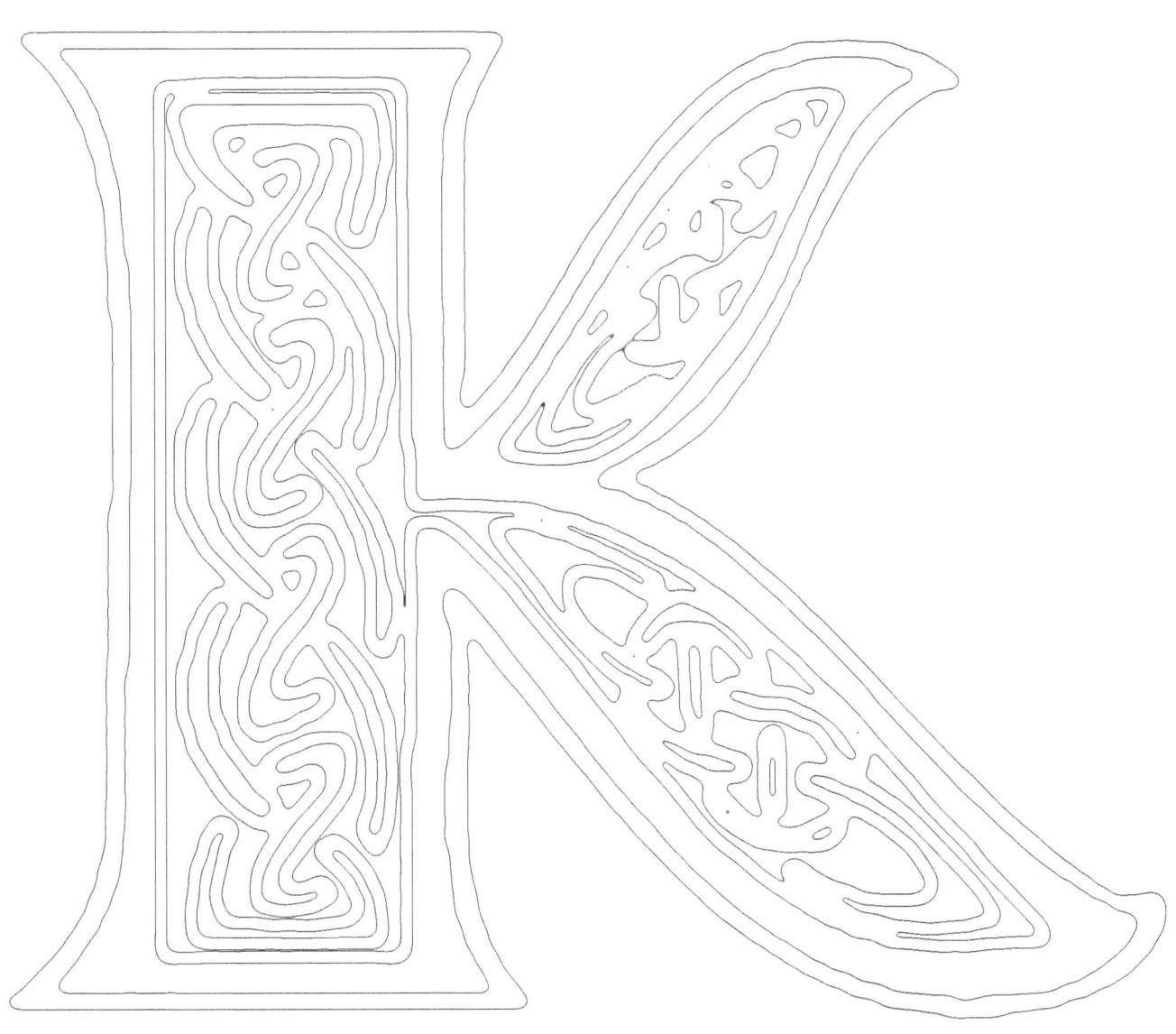

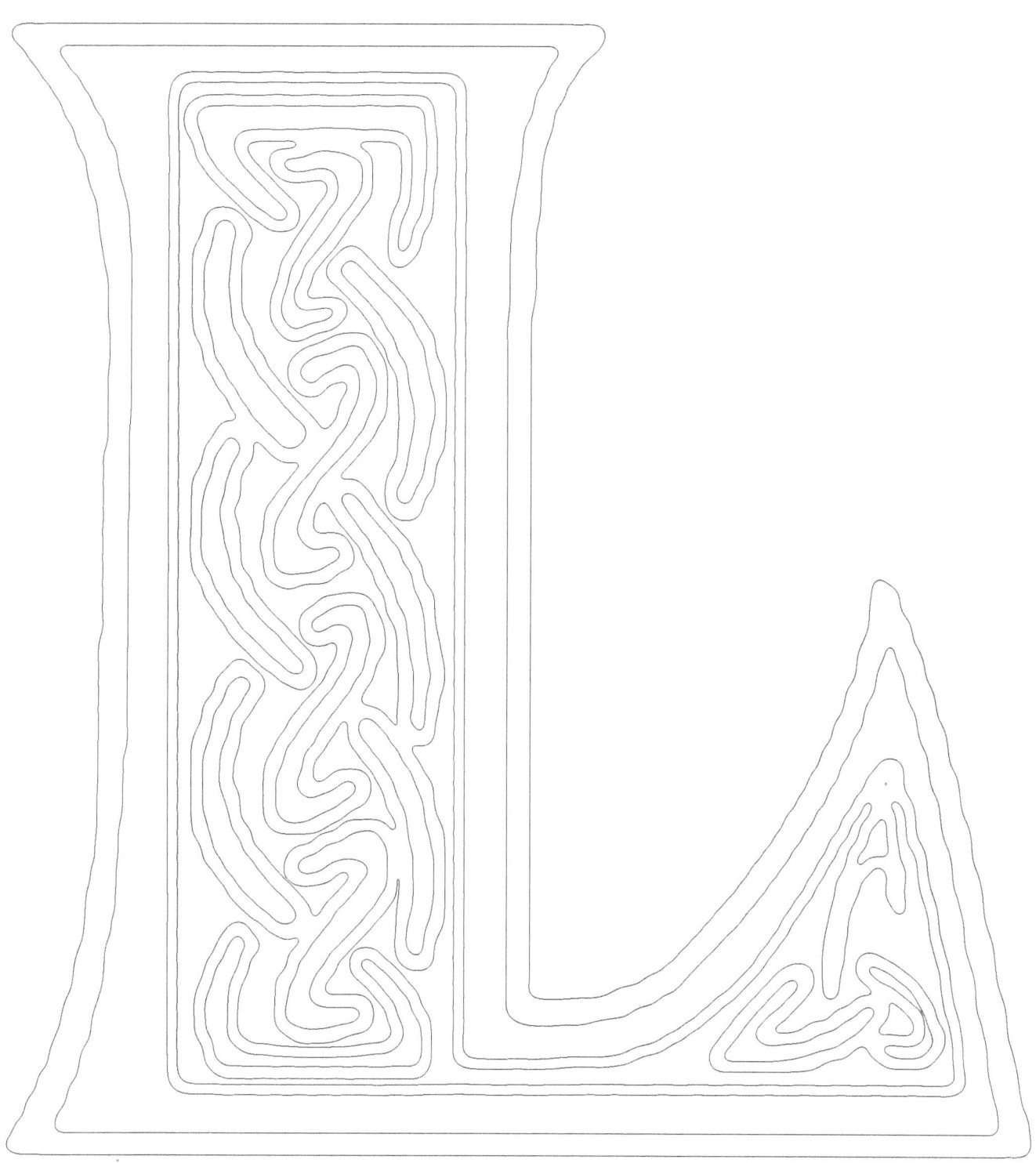

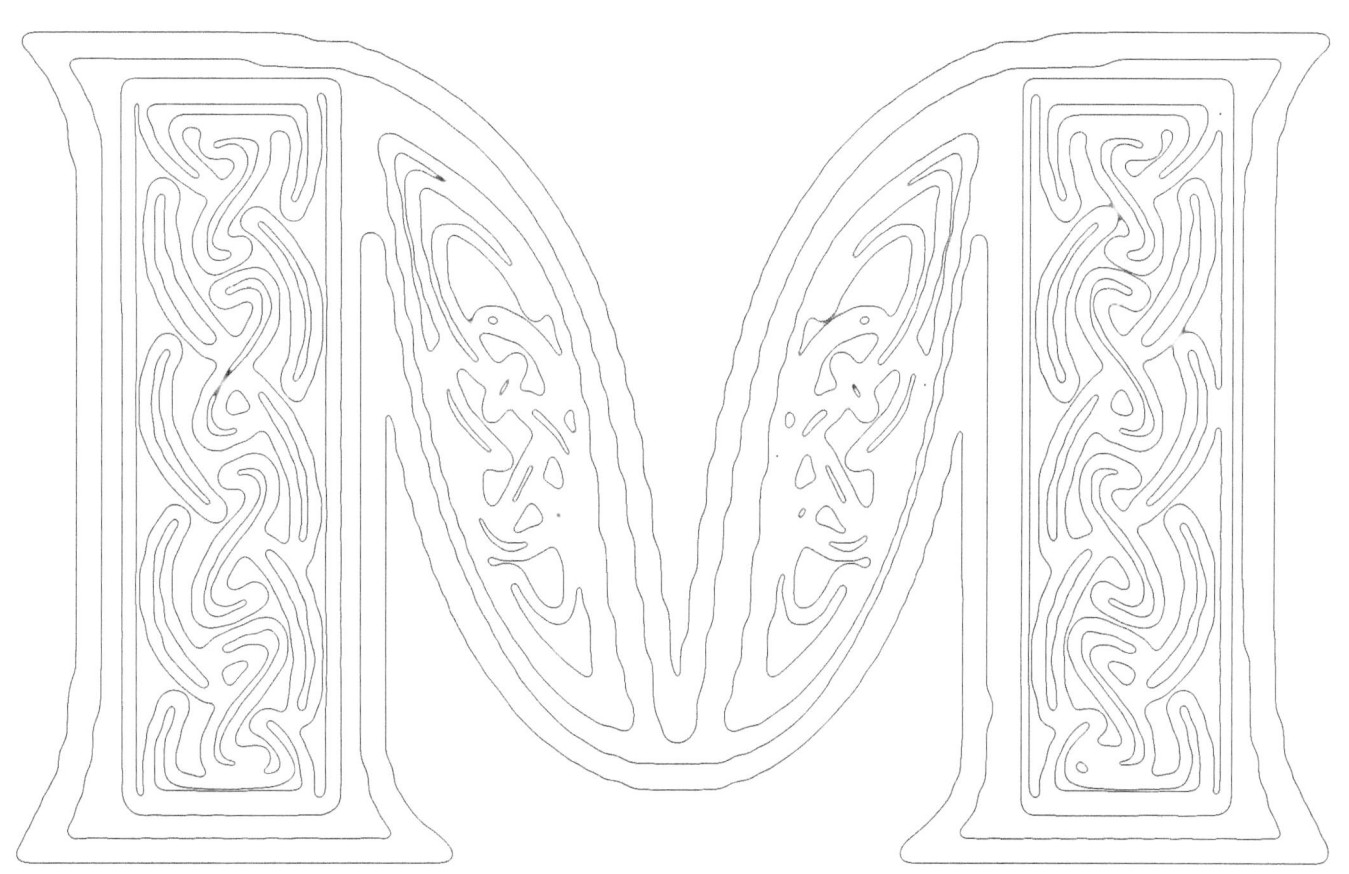

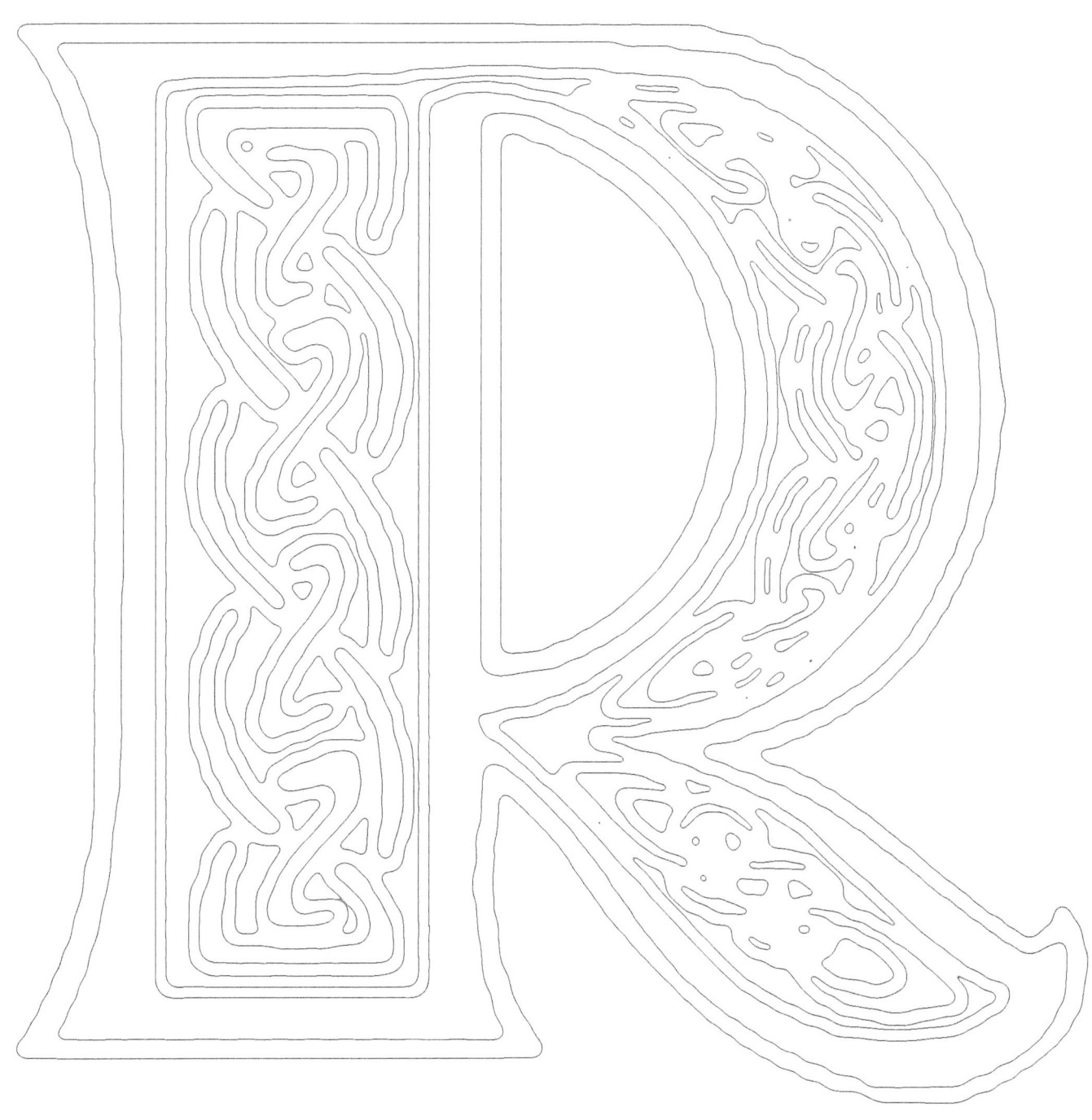

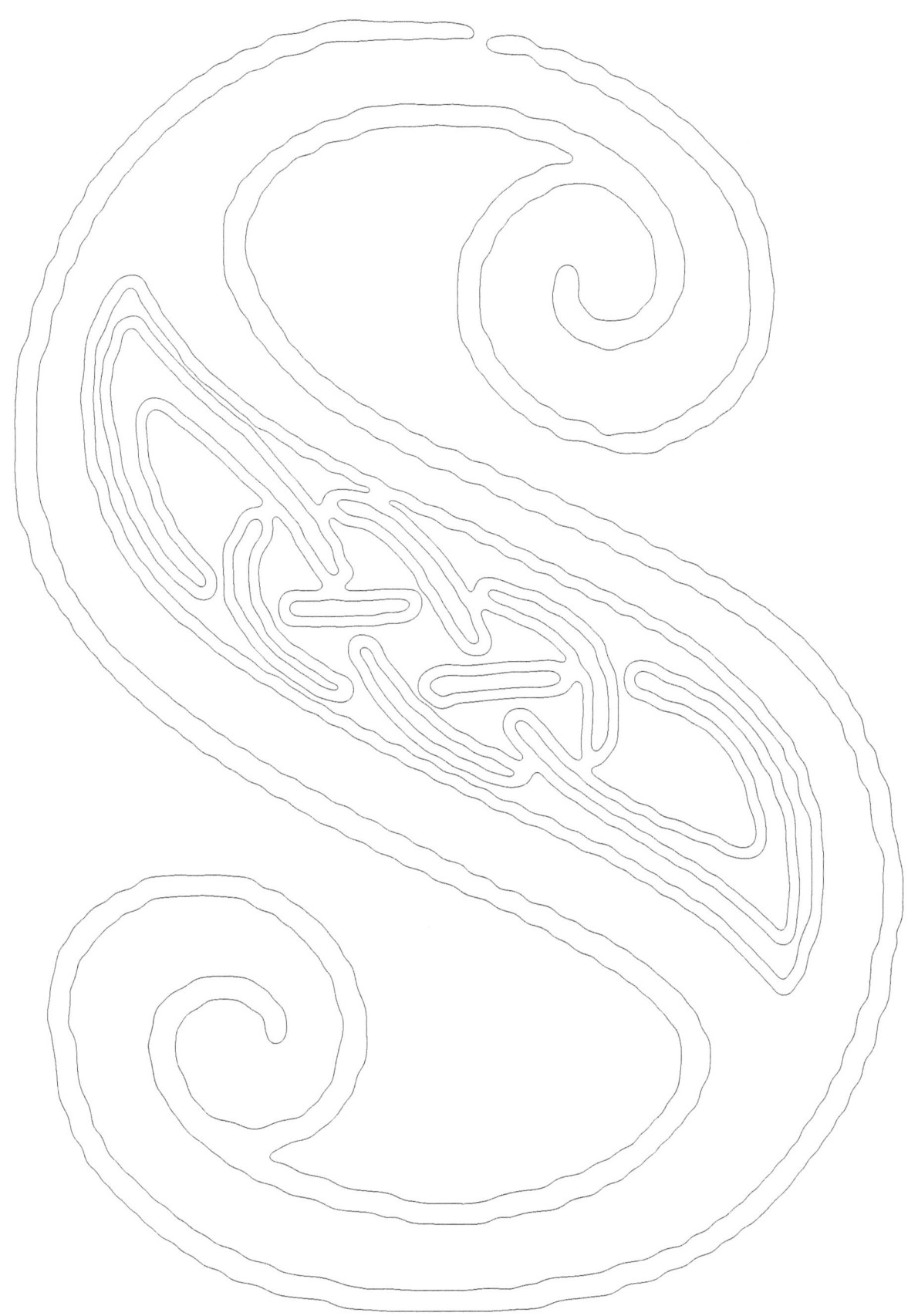

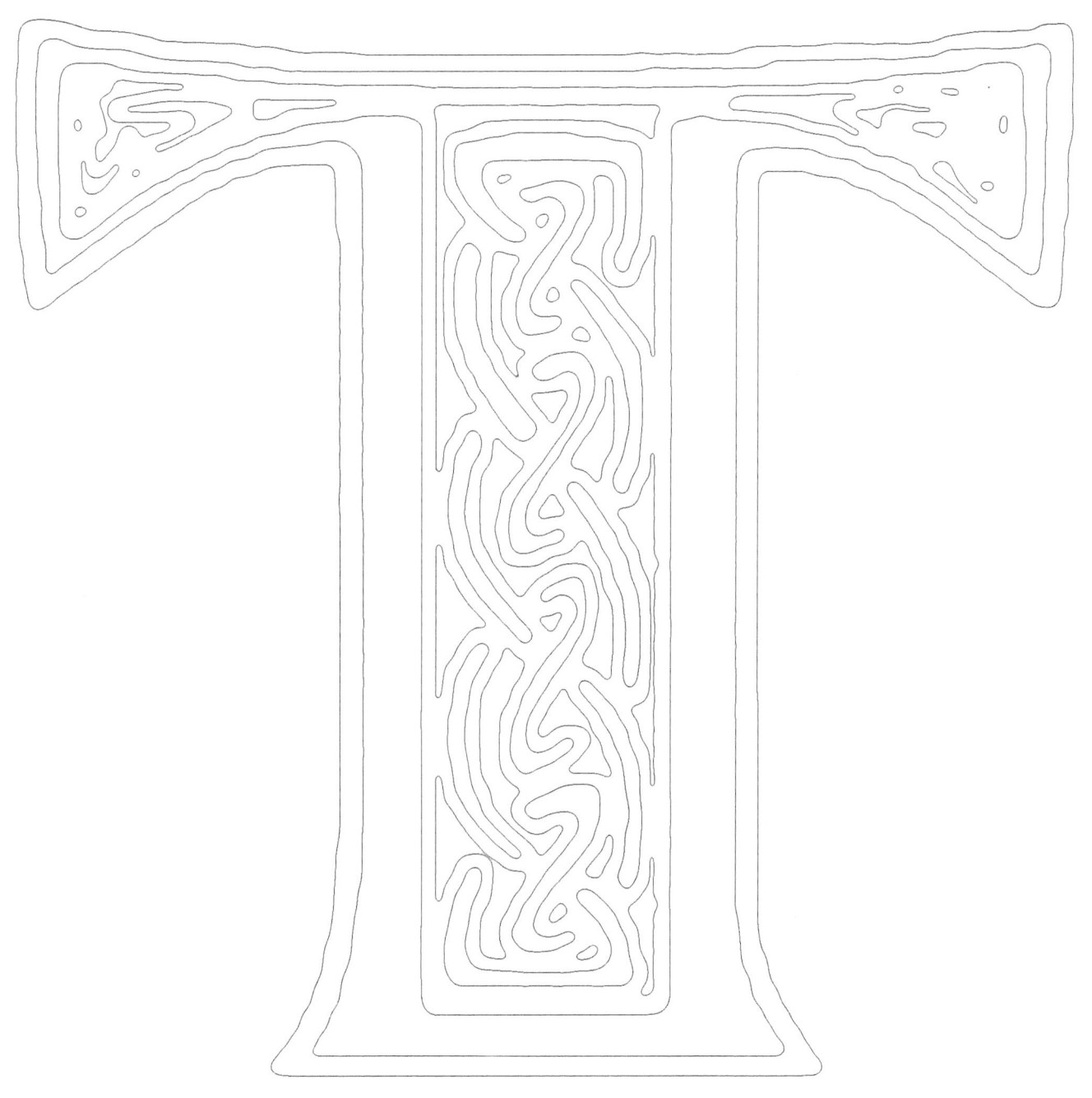

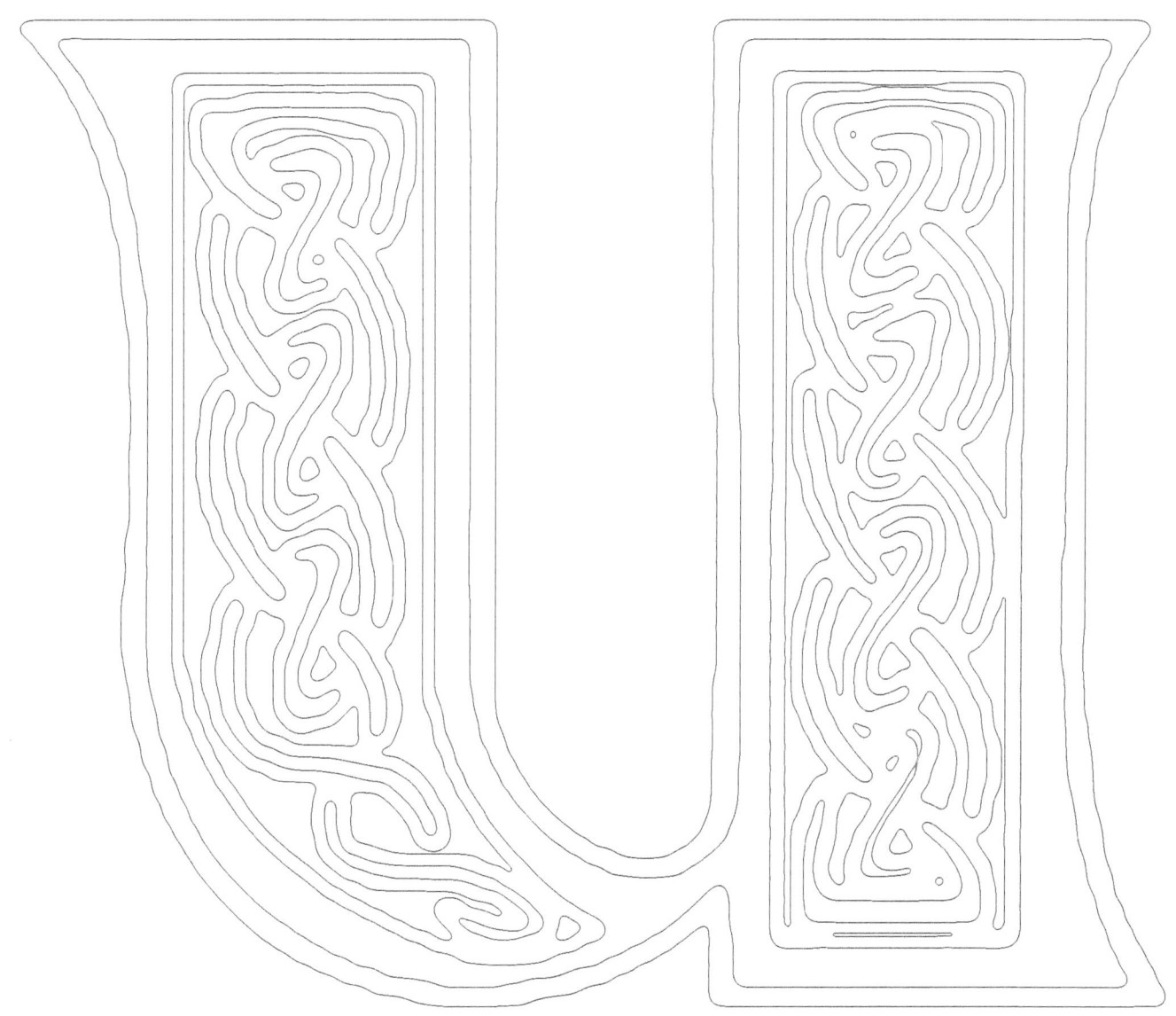

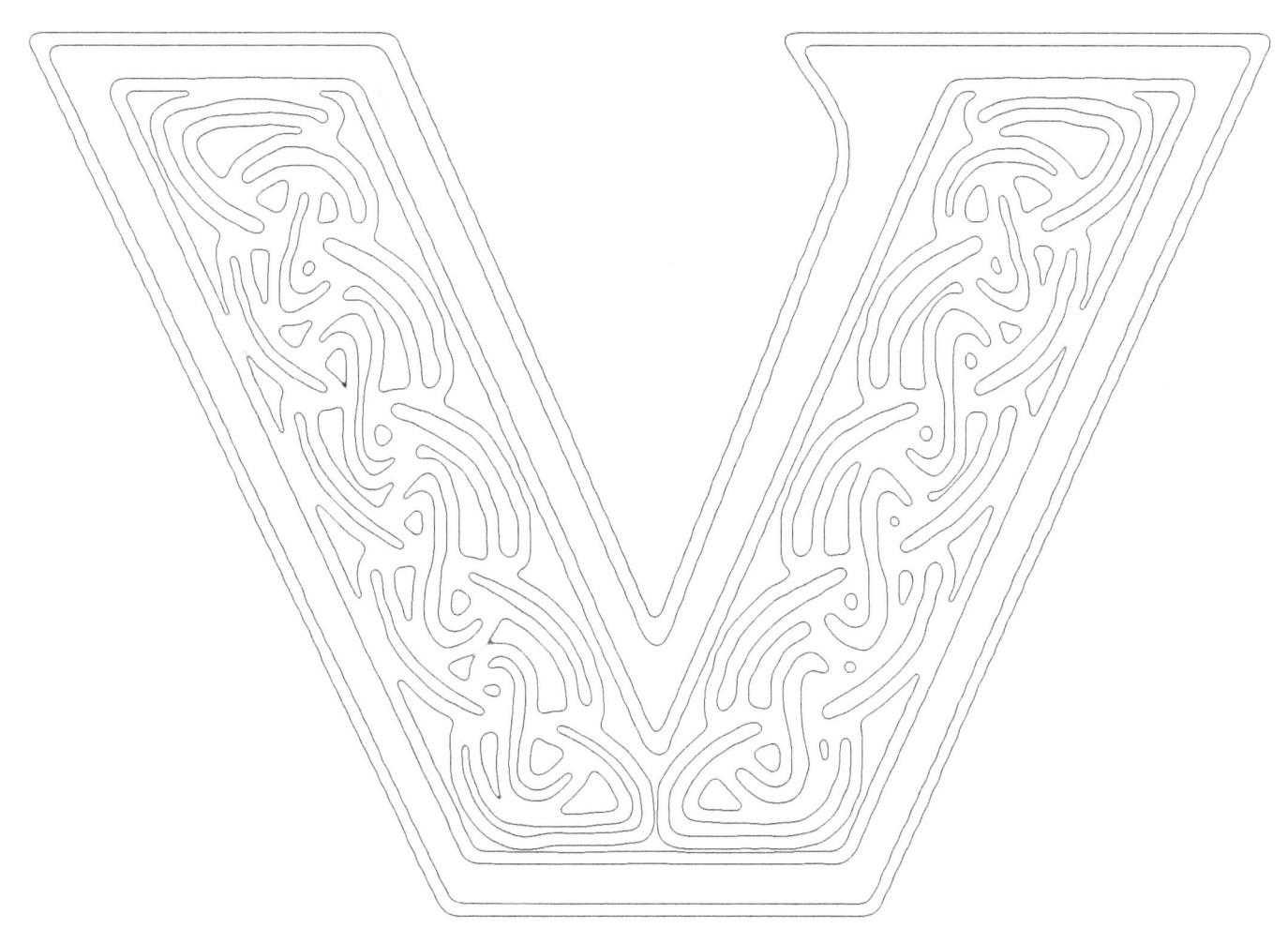

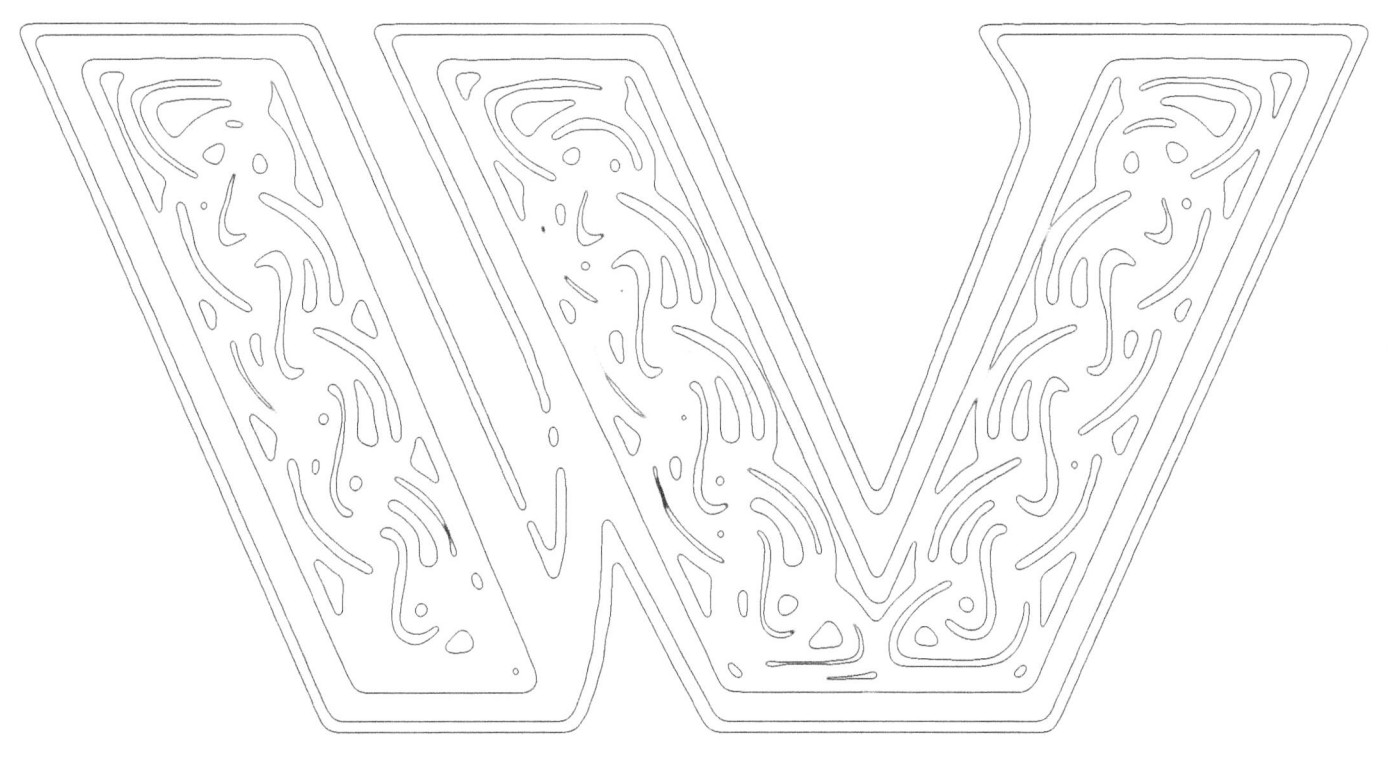

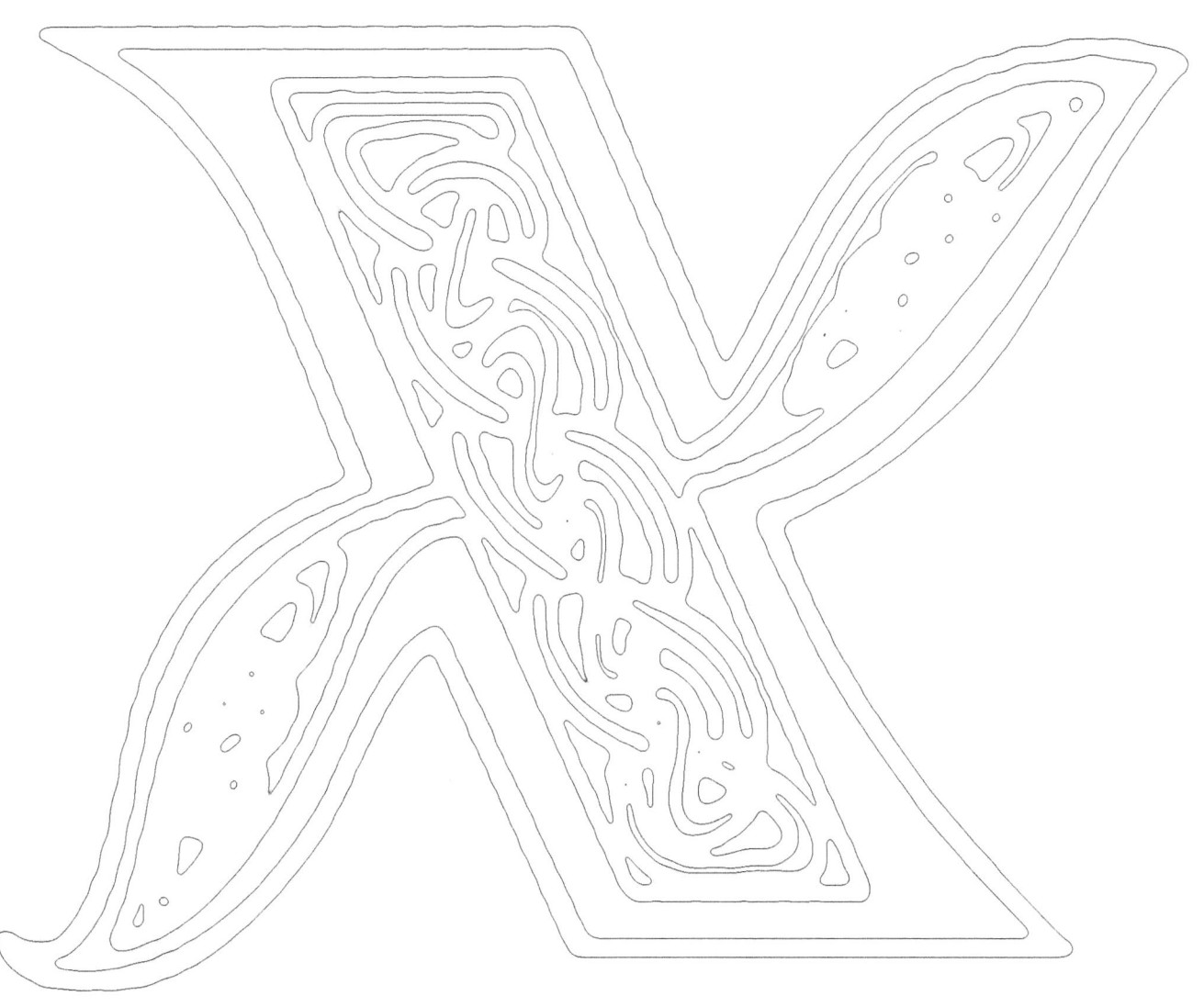